D0362859

Watercolours

Techniques & tips for quick watercolours

Hazel Soan

DEDICATION

To Yassen and his master

First published in 2005 by
Collins, an imprint of
HarperCollins*Publishers*
1 London Bridge Street
London SE1 9GF
This edition published 2012

www.collins.co.uk

Collins Gem® is a registered trademark of
HarperCollins Publishers Limited.

11

© Hazel Soan, 2005

Hazel Soan asserts the moral right to be identified as the
author of this work.

A catalogue record for this book is available from the British Library

Created by: SP Creative Design
Editor: Heather Thomas
Designer: Rolando Ugolini

ISBN 978 0 00 720215 7

Colour reproduction by Colourscan
Printed and bound in China

CONTENTS

Contents

ABOUT THE AUTHOR

Photo: Jackie Simons

Hazel Soan is known to millions through her role as an Art Expert in Channel 4's popular painting programme *Watercolour Challenge*, and through her own series, *Splash of Colour*, made by Anglia TV. She is a highly successful international artist and divides her studio time between London and Cape Town, exhibiting her work widely, and especially at her own gallery in west London.

Hazel is the author of six books on watercolour, including *Collins Painting Workshop: Flowers in Watercolour, Learn to Paint Vibrant Watercolours, What Shall I Paint?* and *Hazel Soan's African Watercolours*.

She has made several videos on painting as well as numerous radio and TV appearances both in the UK and abroad. She contributes to art magazines and also writes a bi-monthly workshop column for the Norwegian Magazine *Kunst for Alle*.

Her enthusiasm and passion for watercolour are well-known. She makes her craft appear simple, possible and straightforward. Many people who thought they would never be able to paint in watercolour have taken up the brush due to her inspiration.

This book is for those people who want to paint but are too busy and do not have the time. Hazel shows how much can be achieved in just 10 minutes! Her website can be visited at www.hazelsoan.com, and a selection of her paintings can be viewed on www.allsoanup.com.

Grand Canal, Venice
15 x 20 cm (6 x 8 in)

INTRODUCTION

I have written this book to provide inspiration for the wannabe artist with no time to paint. Being creative is the thrill of making something from nothing, however modest. The act of even the smallest creation opens our eyes to the limitless beauty around us.

Watercolour is a radiant medium, which reflects light through translucent pigments. Not only is it appealing to look at but it is even more enjoyable to use. It is also an extremely practical medium for painting in any and every walk of life.

Many people say they would really love to paint but just never have the time. However, as we shall see, watercolours can be painted really quickly, and this book will show you how little time you actually need to create something worthwhile. Every painting was completed in 10 minutes or less, unless otherwise stated.

Oranges on the Tree

17.5 x 20 cm (7 x 8 in) Arches paper

Watercolour pigments are a joy to paint with. Here
Cadmium Red and Indian Yellow make a vibrant orange;
Prussian Blue and Indian Yellow make the greens.

LESS IS MORE

With 10 minutes you too can paint a watercolour you will be proud of because the medium, mixed with water and laid down with a brush, is so lovely in itself.

Practised watercolourists will tell you that one of the chief problems with watercolours is the danger of spoiling them by overworking, so the less time you have to paint them the better they will probably be!

This book is arranged in two parts: the first part opens up the medium of watercolour to the reader – the basic materials and how to use them. The second part shifts to specific subjects and shows different approaches to painting quick watercolours.

If you are pressed for time you will not even have time to read this book… so, for the really busy person, I have placed summaries at the end of each section so that you can, in just 10 minutes, grasp the nuggets of watercolour painting and then have a go yourself!

Gondolier
15 x 10 cm (6 x 4 in)
Ultramarine Blue, Quinachrodine Red, Yellow Ochre and Sepia were applied with a size 6 round sable brush.

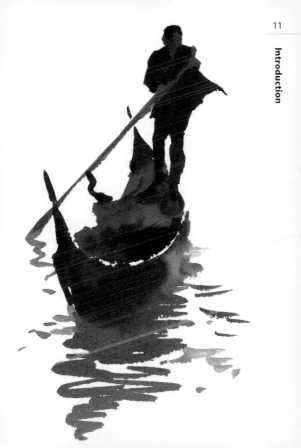

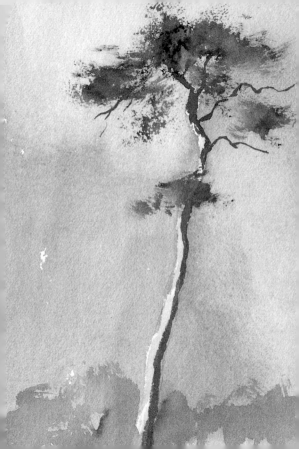

PART ONE

The materials

The choice of watercolour pigments, brushes and paper is overwhelming. To paint quickly, it is essential to limit your equipment. A few colours, one or two brushes, a sketchbook or two, a palette, water and a rag are all you need, and these, in their smallest scale can fit in a pocket or a small bag.

This does not mean you cannot have a greater pool of colours and brushes to choose from but you will not be able to use them all at one time.

Throughout this book many different pigments, brushes and papers are employed and the materials and the size of the image mentioned.

Catching the Breeze
20 x 15 cm (8 x 6 in) Saunders Waterford paper
A size 6 round sable, Prussian Blue, Sap Green and a dash of Alizarin Crimson were used for this pine tree in the breeze.

PAINTS

Watercolour is practical for speed because it is painted on paper, mixed with easily available water and dries quickly. It can be bought in tubes (either 5 ml or 14 ml) or as pans in a paintbox. Artists' quality pigment gives better results and will last longer.

Paintbox
This enamel paintbox was painted with Burnt Sienna and Ultramarine Blue using a size 6 round sable brush.

Watercolour tubes
Indanthrene Blue, Alizarin Crimson and Aureolin were used for this sketch, which was made with a size 6 round sable.

MIXING WATERCOLOUR

Watercolour pigment is mixed in a palette with water and a brush. The amount of water to pigment is the key to successful watercolour painting. The pigments are strong and beginners are often afraid of their intensity and add far too much water, making the colours too dilute. Too little pigment makes tinted water, not vibrant colour.

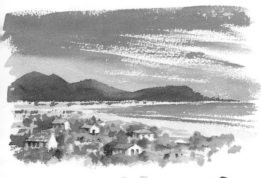

Across the Bay
22.5 x 30 cm (9 x 12 in) Arches rough paper
Ultramarine Blue, Aureolin and a dash of Quinachrodine Magenta were tested out on the bottom of the paper for strength of colour.

USING THE COLOURS

You do not need many different colours to paint in watercolour. Watercolour is so attractive that you can make an interesting watercolour with just one colour.

One colour

Diluting a colour with water creates a variety of tones. Any image can be painted in monochrome which is much faster than using several colours.

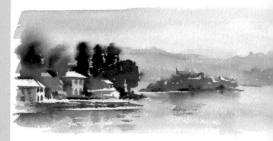

Lake Orta, Italian Alps
12.5 x 25 cm (5 x 10 in) Arches rough paper
Prussian Blue, mixed in varying intensities, made a pleasant one-colour sketch of this Italian lake. A flat brush and size 6 round brush were used.

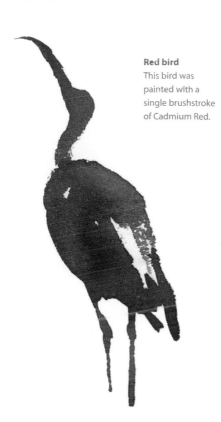

Red bird
This bird was painted with a single brushstroke of Cadmium Red.

Two colours

With two pigments, the range of colour increases as the two pigments blend together to make a third. This varies in hue and tone depending on how much pigment is used of each colour. Two opposite colours will give you a wider range.

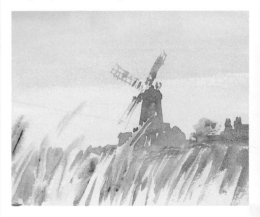

The Windmill at Cley
20 x 27.5 cm (8 x 11 in) Langton paper
Prussian Blue and Raw Umber, used either independently, as in the sky, or mixed together, created a simple windswept view of the windmill.

Three colours

With three colours that approximate red, blue and yellow, the whole range of colour is open to you.

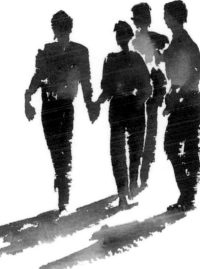

Friends
10 x 10 cm (4 x 4 in)
In this quick study, Cadmium Red, Prussian Blue and Indian Yellow were combined.

CHOOSING YOUR COLOURS

The beauty of watercolour is in its translucency.
Light shines through the pigment onto the white
paper and is reflected back through transparent tints.
Not all watercolour pigments are transparent (they
usually come labelled: transparent, semi-opaque or
opaque). When diluted with water they all appear
transparent, but in overlaying them the transparent
colours allow those below them to shine through,
whereas the opaque colours provide more cover.

To paint quickly you will want to use as few colours
as possible; this is called a limited palette. The clue
to choosing a limited palette is in
finding the right combination
of colours for your subject.

Astermerius
A combination of two
transparent colours
(Alizarin Crimson and
Prussian Blue) and one
opaque (Cadmium
Yellow) made a lively
rendition of this flower.

COLOUR COMBINATIONS

There are three primary colours: red, yellow and blue. With these colours it is possible to mix the whole range of the spectrum. There are many different red, yellow and blue pigments in watercolour. Mixing them will give you a whole range of colour and tone, and by limiting the number of colours you ensure harmony within the painting.

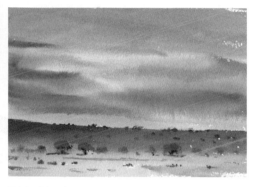

Kalahari Sunrise
17.5 x 25 cm (7 x 10 in) Arches rough paper
Indian Yellow (transparent), Permanent Rose (transparent) and Coeruleum (opaque) were used to paint this sunrise in the African desert.

BRUSHES

The choice of brushes is bewildering – there are different shapes, different sizes and different hairs. You are looking for speed and limited materials so choose a brush made of sable hair. The fibres of natural hair are barbed and therefore hold a lot more of the diluted pigment within the brush head than the equivalent sized synthetic brush. This enables you to cover a large area with one brushload from the palette.

size 10 round sable

12 mm (1/2 in) flat sable

25 mm (1 in) flat sable

mop

rigger

ROUND BRUSHES

Start with just one or two brushes. If you are working no bigger than 25 x 35 cm (10 x 14 in) a size 6 and size 8 round sable are perfect. The round brush has a fat body and a fine tip – ideal for washes and detail.

For making larger paintings choose a 10, 12 or 14. These still have good tips and will enable you to do large washes and broad brushstrokes.

Brushstrokes made with a round sable
These leaf shapes show the versatility of the round sable brush, the fineness of its tip and the breadth of its body.

FLAT BRUSHES

A flat brush is also versatile. It can be used for broad washes and smaller strokes but does not really have the capability for fine detail. It is less expensive than a round sable and the brush head can be used flat on, on its edge or on its side. A large flat brush is great for quickly applying paint, especially over a large area and has a lovely linear stroke when used on its side.

Brushstrokes made with flat brushes

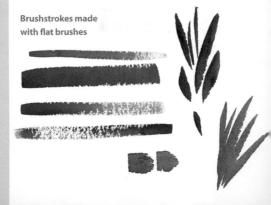

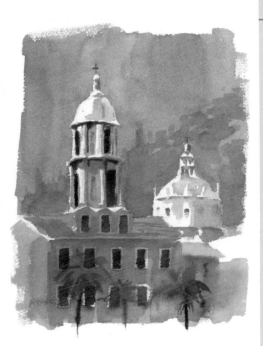

Italian Churches
35 x 25 cm (14 x 10 in)
Flat brushes are ideal for architecture. Three brushes, ranging
from 6 mm (1/4 in) to 25 mm (1 in) wide, were used here.

MOP BRUSHES

The mop brush is a great asset when working at speed. It can be made of sable or squirrel hair, which is less expensive. The squirrel hair brushes are floppier than a sable but their very floppiness imparts a lively freedom to the brushstroke and they have a good tip.

Mop brushstrokes

RIGGERS

The long hairs of the rigger are ideal for fine linear details. Though the brush head is narrow, the hairs hold a lot of pigment, and long, thin lines can be painted with one sweep of the hand.

Rigger brushstrokes

Stargazer lily
The long, narrow brush head of the rigger is ideal for painting fine stamens.

PAPER

The selection of papers is vast but few art shops outside of major cities stock a full range. It is easier to make a good watercolour on a good-quality paper. A rough or not surface (the grain of the paper) is more sympathetic to making quick watercolours. The brushmarks break over the tooth of the paper, adding life to the sketch.

Work with papers of no less than 140 lb in weight, so they do not buckle too much when wet. Sketchblocks are very useful as the paper is stuck down on all sides and they need no preparation in taping down.

If you are working pocket-sized, a small 17.5 x 25 cm (7 x 10 in) sketchbook is ideal, but there is no limit on size even if a watercolour is painted quickly. If you want to paint on large sheets of paper, just use a larger brush. The largest painting in this book is 40 x 50 cm (16 x 20 in). It is easier to paint on a larger sheet of paper: it allows freer brushstrokes.

Sari Ladies
12 .5 x 10 cm (5 x 4 in) Khadi rough paper
The grain of the paper breaks the edges of the brushstroke making a more interesting mark than if the stroke was solid.

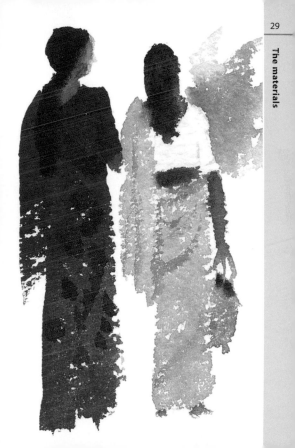

PALETTES

The choice of palette will influence the weight of your materials. A china palette is preferable if you are working at home, but an enamel paintbox or plastic palette is easier for carrying around.

CHINA PALETTES

Mixing in china palettes, with several separate wells, is the best way to judge the strength of pigment. The weight also means that it sits nicely in place and holds down flyaway kitchen roll if you are working outside.

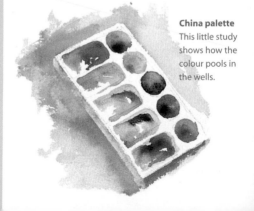

China palette
This little study shows how the colour pools in the wells.

ENAMEL PAINTBOXES

Enamel paintboxes come with folding palettes and
are ideal for travel. If you are painting 'on the hoof',
you will be delighted to find the little finger hold on
the underside of an enamel palette. This enables you
to balance the palette on your hand and the water pot
on the palette, so you can paint absolutely anywhere.

Enamel palette
Even a palette makes a delightful
subject; this watercolour was
made on Arches paper
with lots of colours
and it still
took only
10 minutes.

PLASTIC PALETTES

Plastic palettes are lightweight, and therefore also
good for travel. Since plastic repels water they make it
less easy to judge your watercolour solutions. Choose
one with several small wells for squeezes of pigment,
and larger wells for mixing.

MISCELLANEOUS MATERIALS

Apart from paints, brushes and palettes there are few other items needed. Obviously water is essential but pencils and erasers are optional.

PENCILS

A pencil guide is useful if you want to paint quickly or your subject has details that need noting. An HB or the softer 2B are adequate. You cannot erase pencil marks once paint is applied on top, but nor do you need to.

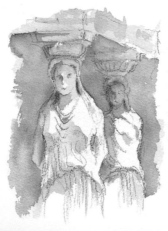

Elgin Marbles, Acropolis
For real speed, watercolour can be applied loosely over a pencil sketch, either in front of the subject or later on.

WATER AND RAGS

Clean water is essential for clear vibrant colours. If the water is muddy, it will tint the watercolour solution. You will need to clean your brush off at any time, so have several lightweight water pots. The small plastic containers from photographic film cassettes are ideal for this, and they also have water-tight lids.

You can use a plastic bottle for a water reservoir, so that if all your pots get muddied you can refill them. Being small, they take little water so you can refresh them often. Being light, you can balance them on your palette, too.

A towel rag or some kitchen roll is very useful. There are times when you will want to take some pigment off your brush for a drier brushstroke, or will need a rag to mop up paint. It can also be used to lift out colour from a wash.

SUMMARY

THE MATERIALS

Paints

■ Use pans or tubes of artists' watercolour. You only need three colours: a red, a yellow and a blue.
■ Suggested reds: Cadmium Red or Alizarin Crimson or Permanent Rose.
■ Suggested yellows: Aureolin or Yellow Ochre or Indian Yellow.
■ Suggested blues: Ultramarine Blue or Prussian Blue.

Brushes

■ Size 8 round sable and/or size 6 round sable.
■ And/or 25 mm (1 in) flat sable brush and/or 12 mm (¹/₂ in) flat sable brush.

Palette

■ Enamel paintbox/china palette with several wells/plastic palette.

Paper

■ Sketchblock or sketchbook of quality paper, weight 140 lb+ (300 gsm). Suggest: Arches or Saunders Waterford, rough or not surface.
■ Any size. Suggest: 25 x 30 cm (10 x 12 in).

Water pots and rag

- 3 x small clear plastic pots, such as empty 35 mm film containers.
- Water bottle: 0.5 litre plastic mineral-water bottle.
- White kitchen roll, white paper serviettes, cotton towel.

Optional pencil and eraser

- HB/2B pencil.
- Small putty eraser.

Beach at Rethymnon
17.5 x 32.5 cm (7 x 13 in)
With just three colours, Cadmium Red, Ultramarine Blue and Yellow Ochre, this beach was painted swiftly over a loose pencil sketch.

PART TWO

Creative zone

Now that you have the materials, you will want to get the best out of them. Watercolour is a lovely medium in itself and is happiest if allowed to act in character rather than being heavily manipulated or overworked. Painting is an act of creation, not of imitation. Keep in mind that you are using the subject matter to create a watercolour, not using watercolour to re-create the subject.

Watercolour success revolves around mixing the colours well and loading the brush with the correct amount for the brushstroke you want to make. It also involves patience as you wait for paint to dry and knowing when to add the next colour. Watercolours, even made at speed, involve planning.

La Chemise
35 x 25 cm (14 x 10 in) Arches rough paper
The rhythm of the pencil marks under the watercolour look lovely under the soft washes.

EXPLORING THE PIGMENTS

If you are new to watercolour the names of all the colours will sound romantic but quite confusing, and knowing which colours to mix with which will be a minefield. Don't panic; all the colours are lovely and choosing a good combination of colours comes with practice. As time is of the essence some suggestions are shown on the following pages to speed up the process, but don't fall into the trap of trying to match colours to the subject: colour is relative, any colour can be used for anything.

REDS

Bright red: Cadmium Red (opaque). Mixes with Indian Yellow for a vibrant orange.

Deep red and rich pink: Alizarin Crimson (transparent). Dilutes to lovely pink and mixes with Ultramarine Blue to form an attractive mauve.

Bright pink: Permanent Rose. Mixes with Cobalt Blue to make a gentle mauve.

BLUES

Warm blue (skies, shadows): Ultramarine Blue. Mixes well with Burnt Sienna for a black.

Cool blue (skies, shadows, seas, foliage): Prussian Blue. Mixes well with Cadmium Red for a rich black.

Sunny mid blue (skies, shadows): Cobalt Blue. Mixes well with Yellow Ochre for the shadows of white flowers.

YELLOWS

Cool bright yellow (excellent for light through foliage): Aureolin. Mixes well with Prussian Blue for bright foliage.

Hot sunny yellow: Indian Yellow. Mixes well with Alizarin Crimson for a rich orange.

Warm glow yellow: Yellow Ochre (semi-opaque). Mixes well with Ultramarine for dull foliage greens but beware of using it too thickly.

GREENS

Although there are many mixed greens among the watercolour pigments, it is usually better to make your greens from blues and yellows, especially if you are using a limited palette. A green can be made both from mixing the blue and the yellow together and from laying yellow over blue or blue over yellow.

Sap Green

Overlaying colours
The leaf was painted with Aureolin first, then a wash of Prussian Blue was overlaid.

Mixing colours
For a duller green, Prussian Blue and Raw Umber were mixed together and the leaf shape painted in one brushstroke.

Dull greens

A really dull green can be made from Ultramarine Blue and Yellow Ochre.

Compare the leaf on the left with this one using Prussian Blue and Yellow Ochre.

TEMPERATURE OF COLOURS

Colours are deemed to have temperatures according to whether they veer to red (warmer) or to blue (cooler). The colder the blue and yellow, the brighter the green.

Cool plus cool

Aureolin is a cool yellow and Prussian Blue a cool blue, and they mix to a bright green.

Warm plus warm

Indian Yellow is a warm yellow and Ultramarine Blue a warm blue and they produce a dull green when mixed.

GREYS AND DARKS

There are many beautiful greys among watercolour pigments, but you can mix greys, browns and blacks with two opposite colours and with any red/yellow and blue combination.

Making greys and blacks
Burnt Sienna and Ultramarine Blue make lovely greys and rich blacks.

Granulating grey
Viridian and Alizarin Crimson make a granulating grey.

Making brown
Violet and Indian Yellow make a lovely brown.

Varying darks
Indigo and Sepia make the
deep black for the penguin's
coat and the greys for the bird.

Tonal change
The brushstroke of
Indigo gradually unloads
on the paper, creating
tonal change. It starts
dark on the head and
lightens over the back
of the glossy coat.

THE LIMITED PALETTE

To paint quickly in any circumstance will require
a minimum of materials. Three colours, one brush,
a palette and water are all you need, but how do you
decide which colours to use?

Look at your subject and find the dominant colour.
If it is a sunset, it might be a red or orange; a seascape,
it might be a blue; a landscape, it might be a green.
Choose your first colour to match this dominance and
then choose two others that will mix well with the
first to approximate the other colours in the subject.

MORE THAN THREE COLOURS

You are not limited to three colours; sometimes you
may need four or five to create the colours you want.
There are also some subjects that are too colourful for
a limited palette: a garden or bouquet of coloured
flowers or the multicolours of a market. However, it is
rarely necessary to include more than seven.

Four Windmills at Cley
25 x 17 cm (10 x 7 in) each painting
Practise painting the same subject with different groups
of three colours and you will soon realize that it is not the
colour accuracy that matters but the tonal balance.

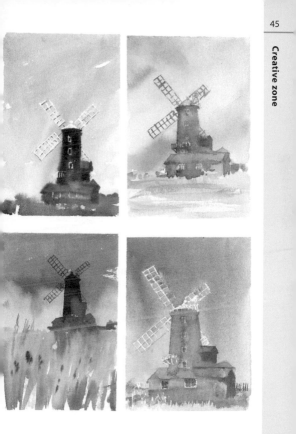

UNDERSTANDING TONE

For a painting to suggest the third dimension on a flat piece of paper the artist must employ tone. This is the term for the light and shade of colours. In its monochromatic form, it is white grading through greys to black.

A watercolour can be brought to life by using and contrasting tones. Pigments become different tones as they are gradually diluted with water. Thus each colour you lay on the paper has both a hue and a tone.

Graduating tones
These graduate from dark to light.

Different tones
Here are three tones of Ultramarine Blue and Cadmium Red: a light tone, a mid tone and a dark tone.

The third dimension

You only need look at banks of billowing cumulus clouds to notice how readily we attribute forms to shapes that grade gradually from pale to dark tones. The more you contrast your darks and lights, the greater the space and depth in the painting.

Watercolours are built up from light to dark. As stronger colours are brushed into lighter colours, tonal variation occurs and the eye imagines the third dimension.

Heliotrope

The form of the flower was suggested by grading the violet hue from a light to a darker tone. The overlap of the leaves was created by contrasting darks against lights.

Building tone in layers

The transparent nature of watercolour means that you can build up tone with successive tints of the same or other colours.

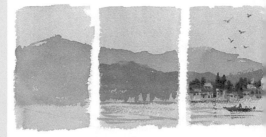

A sense of space
In this set of sketches, the hills were built up with layers of the same tint. A sense of space was created by the advancing tones.

The strength of tone

Just three tones – light, medium and dark – can suggest the third dimension. One of the attractive characteristics of watercolour is the way in which, even within each brushstroke, differences in tone occur as the pigment settles unevenly on the paper.

If ever your watercolours appear flat, you can increase the tonal contrast – set dark tones against light tones and your watercolours will spring to life.

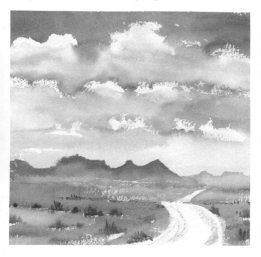

The Winding Road
40 x 50 (16 x 20 in) Arches rough paper
Even if there are lots of colours in a painting, the tones are still active. Here the blue of the sky pales towards the horizon to create space and the right-hand mountains are pale to give a sense of distance.

SUMMARY

EXPLORING THE PIGMENTS

Mixing your pigments

- Use as few colours as possible.
- It is usually quicker to mix paint squeezed fresh from tubes.
- Dilute colours carefully to the right strength (tone).

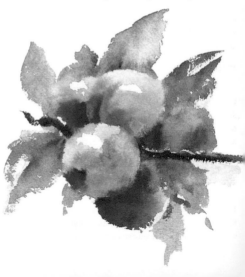

- Keep your mixing water clean.
- Be prepared to add neat colour into wet paint.
- Mix greens from blues and yellows.
- Mix darks from two opposite colours, e.g.
Ultramarine Blue and Burnt Sienna, or Prussian Blue
and Cadmium Red.

Useful three-colour combinations

- Cadmium Red, Prussian Blue, Aureolin/Raw Umber.
- Alizarin Crimson, Indian Yellow/Aureolin, Prussian
Blue.
- Yellow Ochre, Ultramarine Blue/Prussian Blue,
Alizarin Crimson.
- Ultramarine Blue, Burnt Sienna, Yellow Ochre.

Hue and tone

- Build up the watercolour from light to dark.
- With three tones – light, mid and dark – you can
suggest 3D.
- Load your brush sufficiently with pigment so that
a variation of tone occurs even in the brushstroke.

Opposite: Sprig of Peaches
15 x 20 cm (6 x 8 in) Khadi paper
Three colours – Indian Yellow, Permanent Rose and Prussian
Blue – were painted wet-in-wet on slow-drying Khadi paper,
with a little dabbing of kitchen paper to make the edges crisper.

MAXIMIZING THE BRUSHSTROKE

The marks made by the brush are integral to the appeal of watercolour. The aim of the brushstroke is to allow the colours to shimmer and glow on the paper. This creates the freshness enjoyed in watercolour paintings. Painting fast enhances this quality because it requires a speedy brushstroke and forces you to make quick decisions.

Aim to spend more time in the palette than on the paper. Only make your brushmark when you are sure you have colour of the right consistency on the brush. Making the most of the mark made by the brush is even more essential with limited time. If you are going to make every brushstroke count you need to think before you start – and decide what you want the brushmark to achieve.

Avoid going back and forth over the same place in any wash. Lay the paint once and leave it. Do not try to perfect the mark once it is laid; if there are gaps in the brushstroke there is no need to go back over it to fill them in: flecks of white paper in a wash add character and life to the watercolour.

Flamingo
Swift, specific brushstrokes
define the moment of
a flamingo taking flight.
Prussian Blue brushed over
the Cadmium Red created
the black of the wing tips.

USING THE ROUND SABLE

A round sable will hold a lot of paint in its body and still come to a fine point. Practise using this versatility by starting with the tip and then pressing down the body to get a broader brushstroke. The shape of a simple leaf is ideal for practising this.

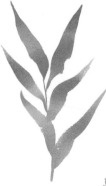

One-stroke leaf shapes
Twist the brush to a point in the palette and touch the paper lightly for the point of the leaf. Press down to make the leaf wider in the middle and then lift and twist the tip up again to narrow it where it joins the stem. Try downward and upward strokes.

Linking shapes
Try more complex leaf shapes by laying one stroke alongside another while wet. Practise using the tip and pressing down the body rather than outlining and filling in.

Three brushstrokes
For this steeple shape, keep your brush tip in the middle of the stroke. Start with the tip, then flatten the brush as you come down the steeple and into the tower. Use the tip again to make the mini turrets on either side.

Heron
Copy the shape of this heron using a mix of Ultramarine Blue and Burnt Sienna and a size 6 brush. Start with the tip of the brush at the beak, press down a little for the head, lift up a little for the neck, press down fully for the body, then lift off so the brush tip finishes the tail. Use the tip for drawing down the legs, pressing down a touch for the knees.

USING THE FLAT BRUSH

A flat sable brush can be used in many different ways to make a variety of strokes, which is especially helpful for architectural features.

Large areas
The flat brush is ideal for covering large areas with an even wash.

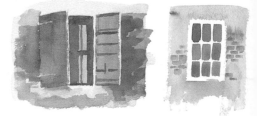

Crisp edges
The straight edge of the flat brush makes crisp edges to the brushstroke, which is ideal for windows, doors and brickwork.

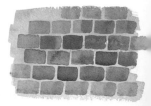

Oblique strokes
Twisting the flat brush
makes a more oblique
stroke which can be painted
with speed and made into
angular and organic shapes.

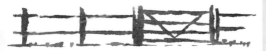

Even lines
Attractive even lines can be made by using the brush head
end on, as shown in this sketch of a fence and gate.

USING THE MOP

The flexible, floppy hairs of a squirrel or sable mop can make lovely lively strokes. Use the brush lightly and loosely at the tip and press down slightly for broader strokes. Keep the brush moving if you want to speed up the action.

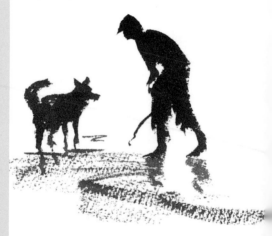

Freestyle stroke
The mop made a lively one-colour sketch of a boy training his dog on the beach. Indigo was used on Arches rough paper.

USING THE RIGGER

Long fine lines can be made with the rigger. If they blend together wet-in-wet they will flow better.

Branches

The brush hairs, though narrow, carry a lot of pigment so the branches of a tree can be painted with a couple of brushloads of pigment.

Rigging

The rigger is ideal for the fine lines of rigging on a boat and even for indicating lettering on the transom. The lines do not need to be solid to be effective.

MAKING INTERESTING SHAPES

Unless you are laying an even wash, the brushstroke is rarely uniform in character. This variety within each brushstroke is very appealing.

To make interesting marks you must let the brush do the work. Be gentle of touch and hold the brush handle lightly. Roll it lightly between the thumb and first two fingers as you lay and shape your strokes. Lift and lower your arm slightly as you lift and lower the brush tip on the paper. Keep your wrist relaxed.

Be daring, less precious. If you find yourself stiff, paint with your other hand for a while, then you will see how lovely the watercolour is when you release control.

Brushmark shapes
Have fun making different brushmark shapes with some sweeping strokes of the round sable. These swatches were made on Bockingford paper.

Stem of flowers
By merging colours wet-in-wet, shapes are made even more attractive.

Ostrich
Try something more specific like this ostrich shape which gives you the chance to use both the tip and the body of the brush.

BRUSHSTROKES TO CREATE FORM

To create form, a variation and contrast of tone is used. This can be done within the brushstroke itself or by adding darker colour into a wash or laying tints on top of other colours.

Convex form

Even slight differences in tone have the power to suggest that something is rounded rather than flat. The greater the tonal difference the more round an object will appear.

Spherical shape
Paint a spherical shape with Aureolin, leaving a patch of white paper as a highlight. With one brushstroke you have created two tones.

Rounded form
With the next brushstroke, touch in intense Prussian Blue from the left-hand side. Let it spread into the damp yellow wash.

Concave form

Not all form is convex. To portray depth and shallow concave indentations, tonal variation is also used. The dimple in this apple where the stalk is attached is a good opportunity to create concave form.

Adding a stalk
The dimple is created by darkening the tone in the dip around the stalk.

Creating form and space
Contrast a dark background against the light side of the apple; cast a shadow and both form and space are created.

BRUSHSTROKES FOR ANGULAR FORMS

Painting over dry washes is necessary to create crisp edges. The washes are brushed one over another in a series of overlapping tints and must not be too wet or they will take too long to dry. Three-dimensional form can be created with the use of three tones, wet-on-dry.

1 Draw a hexagonal shape and lay a wash of colour broadly over it. Let it dry.

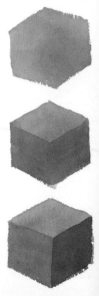

2 Paint a two-thirds chevron sector with the same colour as before. Let it dry.

3 Paint the last third with the same colour and you have a three-dimensional cube. The only thing that took time was waiting for the paint to dry!

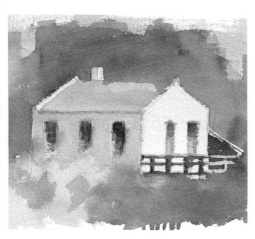

Three tones
Buildings often break down into the three tones: light on the sunlit side, mid tone on the roof, and darker on the shady side.

If your brushmark is too wet but a crisp edge is desired, very gently dab the wet area with a tissue. The next brushstroke can then be introduced quite soon without the two colours merging. Limit the dabbing to the edge of the area concerned so as not to spoil the rest of the brushstroke. A dry brush can also be used to lift out excess water.

PORTRAYING MOVEMENT

People, animals, vehicles and sunsets are all lovely
subjects to paint but are often in motion. This means
you have to paint fast if you are going to capture them.
Watercolour is the perfect medium for portraying

Horses, Sandown
The horses moved too fast for a detailed sketch, but a quick
wash of Burnt Sienna, touches of Ultramarine Blue and
Cadmium Red and a lucky backrun created the impression
of their passing speed.

movement. The dynamism of the swift brushstroke and the speed with which paint can be mixed make a fast painting possible, but also the very energy of the brushstroke itself adds to the impression of movement.

The trailing broken edge of a brushstroke aids the impression of movement. At the end of your stroke, lift the brush tip so that it only lightly brushes the paper, letting the grain of the paper interrupt its flow.

Birds in flight
The beating of the birds' wings is felt in the broken brushstroke.

Moving figure
The broken edge of the brushstroke indicates the movement of the coat.

BLURRING BOUNDARIES

The blending of washes blurs edges and helps create a kinetic effect. To emphasize movement, make the brushstrokes without hesitation and choose their direction to help the flow.

Waving grass
Blades of grass blowing in the wind were brushed across the wet wash of the yellow field.

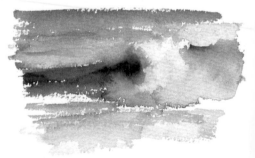

Crashing waves
These were made more dramatic by blurring the colours.

If your wash has dried before you have time to blend in the next colour you can re-create a blurring effect. (The first wash, however, must be completely dry.) Lay clean water over the area where you want to blur the boundaries and slightly beyond it. Brush the new colour into the wetted area and let it blend into the clean water to create a soft, blurred effect.

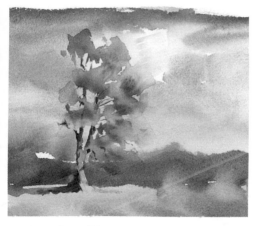

Trees in windy conditions
To show that the leaves of the tree were being blown by the wind, the foliage on the right-hand side was brushed into and blended with the sky.

SUMMARY

MAXIMIZING THE BRUSHSTROKE

Loading the brush

■ For a broad brushstroke, load the brush fully with pigment.
■ When adding detail wet-in-wet, load just the tip with drier colour.

Positive brushstrokes
Rich pigment and confident marks will make dynamic watercolours.

■ Be aware of the amount of water held in the brush head. If necessary, tap, dab or shake off excess water from the brush before entering the palette.

Making brushstrokes

■ Use as large a brush as possible: the tip for detail, and the body for broader strokes and washes.
■ Use the full versatility of the brush, tip to ferrule, for creating interesting and varied brushmarks.
■ Vary the pressure: lift up and press down the brushstroke to prevent uniformity of tone.
■ Avoid going back and forth over the same place.

Shaping your watercolour

■ Make every brushstroke count; there is no time to mess around!
■ Think in shape rather than line.
■ Use the brushmark to shape forms.
■ Suggest movement with directional brushstrokes.

Loosening your stroke

■ If your brushstroke is fussy, try working from further back or stand to paint rather than sit.
■ Hold the brush further down the handle.
■ Use a mop brush.

TECHNIQUES FOR SPEED

Watercolour lends itself to speed. The blending of colours one into the other is one of watercolour's most lovely qualities and it is this technique of painting wet-in-wet that enables watercolours to be painted swiftly and successfully. However, there are also other techniques that facilitate speed.

Oast House

22.5 x 30 cm (9 x 12 in)

Painting in watercolour is quick but drying times can be slow.
A painting with a background will take longer than painting
a motif onto white paper especially if the washes are wet.

THE RIGHT AMOUNT OF WATER

Watercolours are built up on the page from light to dark. Their vibrance is found in using the right intensity of pigment in the washes. Mix the paint too thickly and they lose their transparency; make the colours too dilute and they appear insipid.

Mixing the right amount of pigment to water cannot be easily explained in words – it is a matter of fine judgement – but since most of the watercolours in this book involve very few washes it may help to start by trying to match your pigment intensity to the colours of the paintings featured.

Be brave, be bold; you can always lift out colour with a brush if you think it is really too strong (or, less preferably, dab it off). Very wet watercolour appears darker than it will look when dry, so err on the side of rich, strong colour to start with and throttle back later if you don't like the results.

Becalmed

23 x 15 cm (9 x 6 in) Arches rough paper
Very quick sketches can be made onto the dry white paper. Here the sea was washed in around the boat. It was painted with a mop brush using Indanthrene Blue, Burnt Sienna, Cadmium Red and Aureolin.

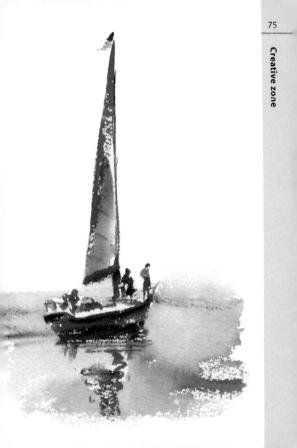

WET-IN-WET TECHNIQUE

Wet-in-wet is probably the most lovely of all watercolour techniques and makes painting fast possible, as you do not need to wait for the paint to dry before you add other colours. It is certainly the most useful if you have limited time. Its success depends on the right amount of pigment and water in the brush.

Practise with one colour

Squeeze some pigment into the palette and mix thoroughly to the required intensity. Make sure your solution is not just coloured water. Lay down your stroke and then re-load the tip of your brush with more of the same pigment. *Do not dip your brush in the water pot.* Add this colour to the previous wet wash and let it spread. The intense pigment will merge into the first wash but will remain darker in tone.

Wet-in-wet
Indian Yellow was used wet-in-wet into Indian Yellow here.

If your second colour is too dilute, it will spread too far into the first wash and create a backrun instead of gentle tonal variation. Remember, if there is already water on the paper from the previous wash, you only need to add pigment.

Rose

If your mixture is the right intensity you can paint detail into a flower while the first wash is damp. This rose was painted with Alizarin Crimson.

Practise with two colours

Squeeze a small amount of two pigments into your palette. Dilute the first colour with water, mixing well. Lay your wash. Rinse off the brush and dab it dry on the rag. Dip just the tip of the brush into the water pot and take a small amount of the second colour and touch it into the centre of the first wet wash. Watch how far it spreads and try again until you get the amount of spread you seek. It may be that the first wash is too wet or too dry rather than the second colour, so be prepared to adjust both.

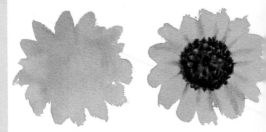

Sunflower
To gain more control of the wet-in wet technique, try this sunflower with its centre of dark seeds. Paint the Indian Yellow shape, then add Sepia for the centre wet-in-wet, but leave small circles out for the seed heads.

Cornflower

Paint the flower with Ultramarine Blue and touch in Indigo or black just before the wash dries to create the dark centre.

Lavender

Make a dull green from Coeruleum and Raw Sienna. Use this and Winsor Violet to paint the sprig of lavender with small alternating brushmarks wet-in-wet.

Lavender leaves

To paint the leaves, alter the concentrations of Raw Sienna as you come down the stem so that the overall colour varies but blends together wet-in-wet.

Practise with three colours or more

The more colours you use, the more prepared you need to be. If your other pigments are not in the palette before you lay the first, the chances are that the first will dry before you can touch them in. After the first wash, the added colours are often very intense and therefore it is not always necessary to mix them in the palette, only to have them ready with the appropriate brush at hand and clean water if needed.

Red daisy
The red petals were painted with Cadmium Red, leaving out the centre. Indian Yellow was added in the middle wet-in-wet so it blended gently into the red. A dry brown was made with these colours and some Prussian Blue and then added below the yellow to give depth. The stem and leaf were painted before the red dried.

Pelargonium

With quick dabbing brushstrokes, the petals were brushed in with Cobalt Violet and a little Aureolin. Prussian Blue and Aureolin were mixed for the leaves. This took no more than 30 seconds.

Sycamore leaves

With the Prussian Blue and Aureolin still on the palette, the leaves were painted. Their shapes were made with the brushstroke (no outlines). The Burnt Sienna stalks were added before the wash had dried. (Note the white paper gap between the two larger leaves to prevent them running together.)

CREATING BACKRUNS

When too much water is introduced by the brush into an already wet wash, the excess water spreads out and pushes the pigment with it, creating patterns called backruns. Sometimes these are clumsy and ruin the watercolour, but at other times they are beautiful and enhance the painting.

Effective backruns are intriguing and are another appealing aspect of watercolour painting. By tilting your paper you can encourage and discourage them.

Sand dunes

A very wet mix of Yellow Ochre and Burnt Sienna was added above the white dune before the sky wash was dry. The colours ran back into the blue wash and created the grasses growing on the dunes.

When practising wet-in-wet technique a lot of unplanned backruns will occur, but it is better to leave well alone. If there is too big a pool of water forming, lift out the excess carefully with the tip of the brush or a corner of kitchen towel.

Ostrich
An accidental backrun created a convenient plume of feathers on the body of this ostrich.

WET-IN-WET WITH WATER

By adding clear water as your 'second colour' into a damp wash, you can use the backrun to lighten an area. Once again it will be your judgement as to how wet the first wash must be and how much water you add with the next brushstroke.

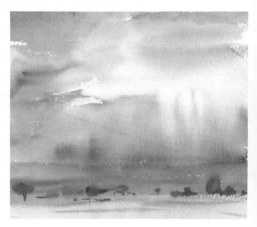

Hail falling from a cloud
This gentle picture was created by dabbing a little clear water into the base of the cloud and tilting the paper downward to encourage it to run into the mauve-grey wash below.

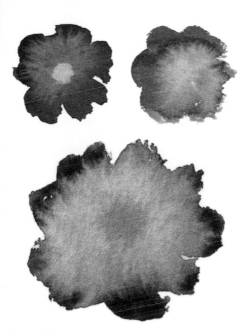

Centre of a flower

Different amounts of water were dropped into each wet petal wash to make the pale centre of a flower. The tip of the brush was dipped in clear water and touched, point down, into the centre of the flower. The paper was kept flat for an even spread.

WET BESIDE WET

There will be instances when painting quickly that you will not want your colours to blend wet-in-wet but neither will you have time to wait for them to dry. Leaving slivers of untouched white paper between washes enables you to complete a painting quickly

Veins of leaves
These are left out of the green wash.

Shading leaves
The curved form of leaves is enhanced by touching in small shadows against the pale lines of the veins.

and avoid the paint mixing. It also looks attractive and will add sparkle to the watercolour.

The white paper acts as a strong highlight so you will need to be discriminate. As a general rule, horizontal white slivers will work on the top sides of objects and in the lie of the landscape, and vertical slivers will work if left only on the lit sides. To protect the tonal balance let the colours merge on the shadowed sides.

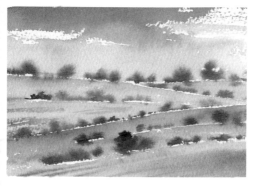

Summer Landscape
13 x 20 cm (5 x 8 in) Arches paper
To prevent the field colours merging, narrow strips of white paper were left between each colour. Do not worry if the colours merge in places; this adds to the flow of the landscape.

DRY BRUSH

More time passes waiting for watercolour to dry than is ever spent painting. The quickest paintings are therefore done either wet-in-wet or with the least amount of water. The dry brush technique enables you to make quick interesting brushmarks and also means that your painting dries fast. The strokes are enhanced when made on rough papers.

How to do it

Mix your paint thoroughly with water, and break down the pigment until you have a creamy mixture in the palette. Load your brush fully. Have a piece of kitchen roll or rag at hand and dab out any excess moisture from the ferrule end of the brush head (not the tip). As you brush the paint across the surface of the paper it should be wet enough to flow across the tooth of the paper in the middle of the brushstroke but appear broken at its edges as the outer brush hairs scuff over the rough tooth.

IMPORTANT POINTS
■ Another colour can be added immediately without it running far into the previous one.
■ A completely broken brushstroke can be made by taking even more water off the brush.
■ Keep the brushstroke moving.

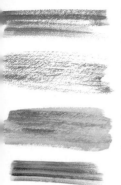

Linear areas
Use a flat brush for linear areas of broken dry brushwork.

Broken brushwork
Drag a round brush on its side for a large area of broken brushwork.

Textured effects
Dry brush can be laid over a wash to create textured ground.

Wood grain effects
These are made with a flat brush.

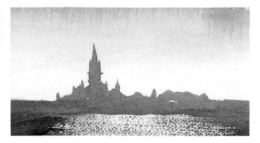

Venice Lagoon
13 x 20 cm (5 x 8 in) Langton paper
The sparkling backlit water is made with dry brushwork.

WET-ON-DRY TECHNIQUE

Watercolour is a transparent medium and can be built up with overlaying tints of colour. However, the underlying wash must be dry when the next tint is laid. This technique is termed wet-on-dry. It creates veils of transparent colour and crisp edges which are ideal for highlights.

With limited time this technique has one inherent problem: you have to wait for the paint to dry before you can add colour on top. This is fine for small paintings and paint that is not too wet, but if your washes are large and wet, unless it is hot or you have

Overlapping colours
Transparent veils of colour overlap to form more colours.

a hair dryer to hand, this technique will probably extend your painting time beyond 10 minutes. You can, of course, start another painting while you are waiting for the first one to dry and therefore paint two paintings at once; two in 20 minutes equals 10 minutes each!

Bell flower

The shape of the bell flower was painted with Alizarin Crimson and allowed to dry. The same colour was added to paint the interior of the bell. The colour was intensified as one colour overlaid the other. The dark centre was added wet-in-wet.

Watching paint dry

Sometimes it is hard to tell if a wash is dry. Never touch it with your finger; instead, turn the paper to reflect the light and note if any sheen remains on the paint or any buckle is left in the paper. If there is, the wash is still slightly damp. *Wait* until the wash is perfectly dry before painting over it.

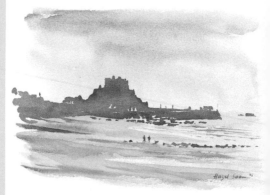

Gorey Castle, Jersey
25 x 35 cm (10 x 14 in) Saunders Waterford paper
The washes for the sky and beach dried quickly which
enabled the castle to be added without delay.

Bell flower

If you want an edge to one side of your second wash, pat that area lightly with a rag just before the wash dries so the colour only spreads in one direction.

Interior colour

While the second wash is wet, a colour for the deep interior can be touched in from the same crisp edge so that it too spreads out in one direction only.

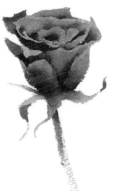

Rose

The petals on this rose were painted wet-on-dry. Compare this rose with the wet-in-wet rose on page 77.

COMBINING TECHNIQUES

In most watercolours a combination of both wet-in-wet and wet-on-dry techniques is used.

Anemone
In order to make the centre dark, Indigo was added wet-in-wet. When this wash had dried, the petals were created on top wet-on-dry. Within each small wet petal, darker colour was touched in (wet-in-wet) to give depth.

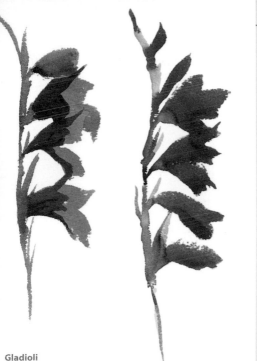

Gladioli

These two stems of gladioli use the wet-in-wet technique, but the one on the left has taken longer because of the addition of outer petals wet-on-dry. Both are equally attractive.

SPONGEING

Brushmarks can be made with tools other than brushes. The pocked surface of a natural sponge dipped in watercolour and patted on the paper gives the painter a very quick way of creating a speckled effect.

Sponge marks
The basic sponge mark is shown (left). Successive layers of sponged marks (below), made either wet-in-wet or wet-on-dry, will build up colours and tones.

The sponge uses a lot of paint, so mix up plenty of pigment into a rich, creamy solution in the palette. Wet the sponge with clean water to soften it and squeeze it out until almost dry. Dip the sponge into the mixture and pat it on the paper, twisting and turning the sponge in your hand to avoid a repetitive pattern of the sponged shape.

Spongeing foliage

The natural sponge is ideal for painting trees. As the sponge is pressed down on the paper, attention to the main forms of the foliage gives the tree volume.

Spongeing over a wash

This tree was sponge painted over a sky wash on Saunders Waterford paper. The wash was not quite dry so the sponge marks have blended on the damp paper creating a softer look.

WAX RESIST

Another quick way to create texture is to use a white wax candle. Water and grease don't mix so wherever you draw on the paper with the end or side of the candle the watercolour will not settle. Across the surface of the paper the wax makes an uneven mark. When watercolour is brushed over this a lovely texture is created.

Using a candle

Lines are made from the end of the candle (above left) and areas made from the side (above right). The wax can be rubbed on top of watercolour so that a previous wash can be seen shimmering through the wash on top (below).

Beware!

The grease from fingers will also resist watercolour, so be wary of touching the surface of your paper while you are working.

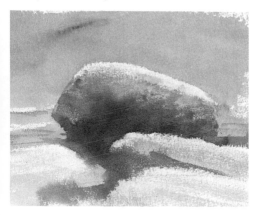

Textured Rock
27.5 x 35 cm (11 x 14 in) Arches paper
Ultramarine Blue, Viridian, Cadmium Red, and Yellow Ochre were used for this sketch. The highlights of the rock were waxed before the sky, sea and rock were brushed in with a 25 mm (1 in) flat brush. When this dried, the wax was used again to hold back the mid tones from the next wash which was freely applied with a big brush.

FANNING BRUSH HAIRS

When you dip your sable brush in the pigment solution, the individual hairs of the brush each hold a certain amount of pigment of their own. If you separate these hairs with your finger and thumb before laying the brush stroke on the paper, fans of thin lines can be painted.

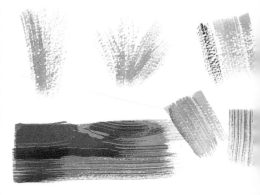

Grass clumps and wood grain

A fanned brush is ideal for painting grass clumps (top left and centre), while wood grain (above) is painted easily by separating the hairs of a wide flat brush.

SPATTER

Spattering the paint from the brush onto the paper creates a random speckled effect ideal for foreground interest. It can be used to denote ground textures, flowers or just to add character to the painting. You can also use a toothbrush or diffuser to make a sprayed spatter effect.

Road in a landscape

The landscape on either side of the road was masked with kitchen roll to protect it from spatter, which was made with Yellow Ochre and Ultramarine Blue plus Burnt Sienna.

Beach

By bravely spattering the paint from above, with a flat brush in a fast sideways hand, movement texture was created on the beach.

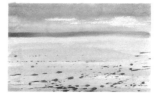

SUMMARY

TECHNIQUES FOR SPEED

Wet-in-wet

■ Use the right amount of water to pigment to make rich colours rather than tinted water.
■ Add drier paint into wet washes so the colours blend and the edges are soft.
■ Add neat pigment into wet washes for minimal spread and stronger tonal contrast.
■ To create backruns, add very wet colour into wet washes.
■ To prevent wet colours running together, leave slivers of white paper between washes.

Bush boots
Different techniques are often
used together in a painting.

Dry brush

■ Load the brush with diluted pigment, dabbing off excess dampness on a tissue.
■ Drag the brushstroke across the paper so the brush skips over the tooth, creating a broken brushstroke.
■ Small, strong, dry brushstrokes can be made with undiluted paint.
■ Rough paper enhances the dry brushmark.

Wet-on-dry

■ Lay transparent watercolour tints over dry paint to build up colour and tone.
■ Wet washes take time to dry so lessen the amount of water in the brush.
■ Make sure the wash beneath is absolutely dry before applying additional colours.

Spongeing

■ Use the patina of a natural sponge to pat paint onto the paper.
■ Prepare plenty of paint to a creamy texture in the palette.

Wax resist

■ Rub candle wax onto the paper or over dried washes, then paint over the wax to create texture.

WHAT TO INCLUDE

'Less is more' and 'most said with minimum means' are the mottos of the watercolourist. The temptation to include too much in a painting is a common trap. The beauty of painting in 10 minutes is that you are forced to select that which interests you most, so this problem should not arise.

Of course, you are not obliged to include everything you see, nor to even record what you see with any form of accuracy. The watercolour will work if the composition, tones and colours are presented in a fresh and vibrant style.

Sunflower
A wet-in-wet
suggestion of
petals and seeds
is all you need
to paint a
vibrant flower.

Trees Turning
18 x 13 cm (7 x 5 in)
A few simple blobs of wet-in-wet paint and a
judicious backrun herald the arrival of autumn colours.

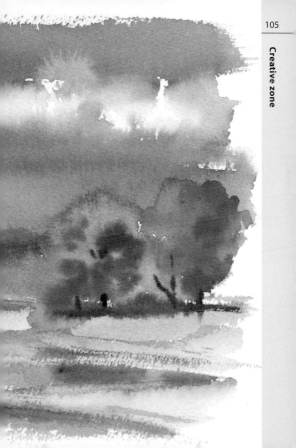

FINDING THE FOCUS

How do you decide what to leave in and what to leave out in a painting? First remind yourself that you are using the subject to create the watercolour, not the watercolour to re-create the subject. Ask yourself why you want to paint this particular view or thing.

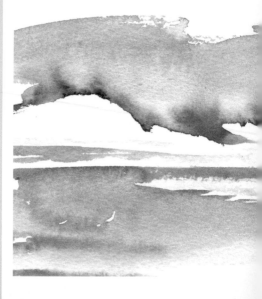

Your answer will tell you the focus of your painting.
It might be the sweep of a mountain, the brightness
of a colour, the twist of leaves or the expanse of sky –
that becomes your focus.

Boys on the Beach
18 x 35 cm (7 x 14 in) Saunders Waterford paper
The children playing in the sand are the focus of this painting.

ACCURACY OR AMBIGUITY?

The viewer's eye will imagine much more detail and description than the painter need give it. Let the watercolour blends be ambiguous and the eye will imagine the detail.

It is far more important that your watercolour looks lovely on the page than that it is accurate. If you have created a successful patch of blended colour, do not

spoil it because it does not accurately represent the subject. Once away from the source of inspiration your painting will be judged by its attractiveness as a watercolour, not by its truthful rendition of the object or scene.

One of the problems with learning to paint from photographs, rather than life, is the tendency towards slavishly including everything that appears in the photograph. In front of the subject the painter would have to make a selection and leave out the rest. Thankfully, with only 10 minutes' painting time, you will not fall into this trap.

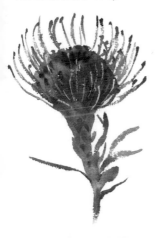

Pincushions
Neither of these watercolours is a botanical study, but this one is a more accurate rendition However, the painting on the opposite page has more appeal as a watercolour.

THE MAIN TONES

In painting, the tones are more important than the colours themselves. The lights and darks and mid tones of the colours matter more than the actual hue. Therefore a good composition, or even a small detail, is likely to be one with a good tonal balance.

Tone is relative, so light tones against darker tones, and vice versa, help each other stand out. This tonal counterchange helps you to decide what to include in your painting: look first for the main tones. To make this easier, half-close your eyes; the main tones will stand out and details will be less distinguishable and no longer distracting. Note these tones in your mind and your composition. Mix your colours to match the tone rather than the hue.

Yassen

15 x 25 cm (6 x 10 in) Langton paper

There is no need to show every hair or marking; just look for the main lights and darks. The nose is light against the back, the tail light against the leg, the haunch light against the stomach and the muzzle dark against the shoulder. (This took a little longer than 10 minutes but I promised my son I would include his faithful dog!)

COMPOSITION

With only 10 minutes to paint, your compositions are going to be fairly simple, but you will still want to pay attention to the layout of the design on your page. The centre of focus is usually better off to one side of centre and below or above the middle line.

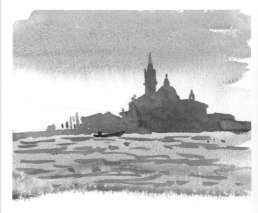

San Giorgio
15 x 20 cm (6 x 8 in) Langton paper
Avoid centre horizons – they are better placed low down or higher up on the page. Create variety in the shape and form of the brushstrokes wherever you can.

BACKGROUND OR NOT?

Throughout this book you will see that some paintings are painted straight onto the white paper whilst others include backgrounds. You cannot successfully 'add' a background; it must be integral to the painting from the start.

Giraffe

This giraffe (right) was painted onto the white paper with a spatter of dust behind the hooves. The sketch below took longer, waiting for the background wash to dry.

PROPORTION

Most people automatically sketch and paint 'sight-size'. This means that if you held up a pencil to your subject and measured the relative size of the subject against the pencil's length it would most likely be drawn that size on the paper. (This does depend to some degree on your chosen paper size.)

It therefore holds that it takes a touch more effort to enlarge or reduce your sketch to fit a larger or smaller paper size. If you have difficulty drawing the proportions, use your outstretched pencil to compare the size of things, one against another.

Reclining figure
Look at the proportion of the head to the rest of the body and especially the length of the legs.

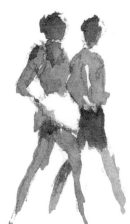

Strolling figures
When painting adult figures, you will find that on average the head goes into the body about seven or eight times.

Woman in blue
Sometimes, however, this rule is broken!

KNOWING WHEN TO STOP

You may think that 10 minutes is a very short time to make a watercolour but there are lots of pictures in this book that took five or less. You therefore also need to know when to stop.

Do not overwork paintings

More watercolours are lost by overworking than by underworking them. While a painting is fresh and transparent it has life; once you destroy the freshness of the washes or introduce too much opacity the watercolour, though not necessarily lost, will take a while to retrieve and 'fiddling' will begin. So keep it simple, keep it fresh. Do not take your brush back

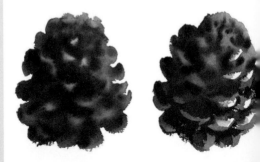

and forth over an area, nor add details that are not needed in the watercolour. Learn to read your own watercolours and to recognize when something lovely is happening and let it be.

'Lay it and leave it' should be the motto for your washes as the first wash is usually the freshest. And remember that watercolour is such a lovely medium in itself that it needs very little to say a lot.

Pine cones

Painting with watercolour is such a pleasurable experience that there will be many times when you just do not wish to stop. Rather than overwork a painting start another... and another... and another!

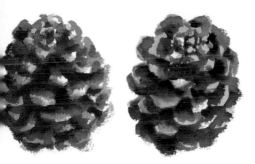

SUMMARY

WHAT TO INCLUDE

Find the focus

- What has attracted your interest? Make that your focus.
- Look for the main tones.
- Only include that which you have time to paint.
- Decide whether to paint the subject directly onto the paper or whether it needs a background. (Including a background may take longer.)

Koi in a Pond
20 x 30 cm (8 x 12 in)
I started to paint the koi but found 10 minutes was not enough time really to do them justice in their setting.

■ If there is no background, work outwards from around the centre or focus.
■ Use the subject to paint a watercolour, not the watercolour to paint the subject.

The art of suggestion

■ Use the minimum amount of description to suggest much more: most said with minimum means.
■ The wet-in-wet technique enables you to suggest rather than actually paint detail. Draw into the wet washes with dry brush or neat paint.
■ Allow ambiguity in the washes.

Finishing a watercolour

■ Recognize when something attractive is happening on the page. This may be the time to stop.
■ Do not be a slave to accuracy.
■ Overworking a watercolour can kill its freshness.
■ Keep it simple in concept and composition.
■ Do not fiddle.

Three koi fish
I realized that what I was really interested in was not the scene but the markings on the fish, so I spent the next 10 minutes happily painting just the fish themselves.

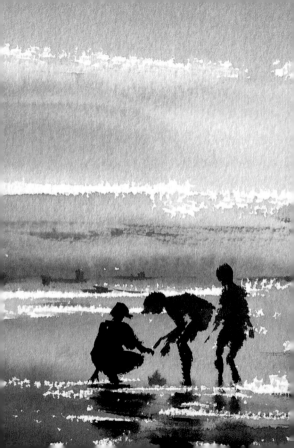

PART THREE

Painting in practice

This section is devoted to specific subjects. The method, colours, paper, brushes and time taken are often mentioned to give you the confidence to practise similar subjects, or copy the ones shown here.

Get your materials organized before you start, even for the shortest painting session. Be prepared to waste paper and make mistakes. Do not be over ambitious; paint only that which interests you most and think about how much time you have and what is possible to achieve within that time.

Beach Combing
25 x 17.5 cm (10 x 7 in) Arches rough paper
This painting took 10 minutes but five of those were spent waiting for the background to dry!

PEOPLE

There seems to be general trepidation about painting people. For the painter, they are no different to other subjects except that they are usually moving which makes their shapes difficult to pin down.

People on the beach are probably the best models because they hold useful poses for quite a time and are without the complication of many clothes.

Figures on a beach
These sketches were made on a beach in Crete with colours already in the palette. They were painted all over a large sheet of Bockingford paper with a size 6 round sable. Each one took no more than a few minutes.

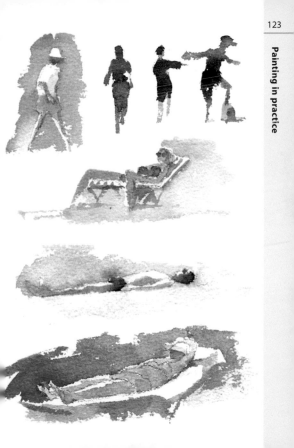

PORTRAITS

It is very satisfying painting the faces of those you know and love. Family and friends may not be the most patient models, so they will be relieved to hear it will only take 10 minutes!

Skin tones

A loose portrait likeness can be built up quickly by first laying a ground wash of skin tone (here, Yellow Ochre) with a large brush. This covers everywhere but the highlights. Into this a little Alizarin Crimson is brushed, wet-in-wet, on the shadier side, then more darkly under the chin and beside the eyes.

Around the eyes

A smaller brush is dipped in neat Alizarin Crimson and Ultramarine Blue for the lines around the eyes. Because the first wash is still damp this spreads gently upward.

Finishing touches

The hair is brushed in with vigorous strokes of Yellow Ochre and a touch of Ultramarine Blue. The shirt is left until last, when the sitter has tired of holding the expression.

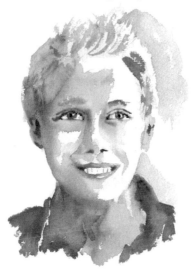

Sean
30 x 22.5 cm (12 x 9 in) Arches rough paper
Colours: Yellow Ochre, Alizarin Crimson, Ultramarine Blue
Brushes: sizes 6 and 10 round sables
Time: 10 minutes

SEATED FIGURES

People sitting or waiting are ideal subjects for a quick watercolour. Railway stations, trains, buses and bus stops, airports and shopping precincts yield an abundant choice of poses.

Leaving highlights
I worked with rich wet paint, starting with the head and hands to position the torso. I painted in the body so the colours ran together, leaving untouched white paper for highlights.

White clothes
I painted around the white clothes with a background wash to bring out their shape.

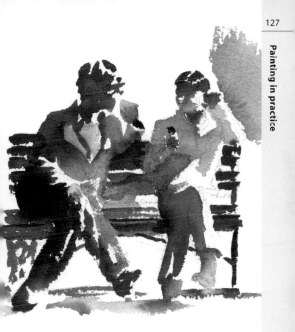

Chinese Whispers
12.5 x 12.5 cm (5 x 5 in) Arches rough paper
Colours: Cadmium Red, Yellow Ochre, Indanthrene Blue,
Winsor Violet
Brush: size 6 round sable
Time: 12 minutes (oops!)

MOVING FIGURES

Painting a moving figure requires speed. Think of people as shapes of coloured tone and work wet-in-wet so the colours blur, adding to the sense of movement.

The figures shown on the opposite page are approaching. You can tell they are walking because one foot appears higher than the other. The actual feet are not painted, just the shapes of the legs and the spaces between them. The blending colours create fluidity in the pose.

Gondolier

This gondolier was painted in a similar way to the figures opposite. The gondola was blended into the legs and the reflection merged into the boat.

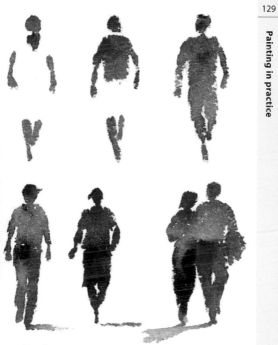

Strolling figures

The figures were painted with Burnt Sienna as a base colour for the head and limbs. The colours of their clothes and hair were added before the Burnt Sienna dried, so the colours blended.

CROWDS

A crowd can be quickly painted, especially if the group of people are backlit by the sun: white halos of light outline their forms and these serve as white paper margins between wet washes.

Figures in crowds

A crowd shifts, so paint each figure individually, starting with the closest. Allow for the margin of light above their head, on their shoulders and down the arms (i.e. do not paint the head too big). For your next figure choose a person who has moved into the place beside or beyond them and again leave space for the white paper highlights. The background figures are painted as just heads and shoulders above the halo of light, with their own margin of light between them and the background.

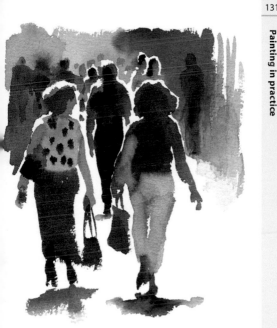

Shoppers in New York
15 x 10 cm (6 x 4 in) Arches rough paper
Colours: any available in palette
Brushes: sizes 8 and 6 round sables
Time: 10 minutes

SILHOUETTES

Strong backlight sends figures into silhouette – ideal for a quick painting since it requires only one or two colours. Do not be afraid to mix very dark, almost neat colour in the palette. The immediacy of the first brushstrokes will be more effective than if you have to darken them up with additional pigment on top.

Mixing two opposite colours makes interesting darks. In the canoeist sketch, Winsor Green and Purple Madder were combined. The slight variation in pigment adds interest to the colour. Satisfying blacks can be mixed with Alizarin Crimson and Viridian, Burnt Sienna and Ultramarine Blue, Cadmium Red and Prussian Blue or Indigo and Sepia. Silhouettes don't need to be black; they can be any colour and any tone.

Canoeist
Leave slivers of untouched white paper between the brushmarks for highlit top surfaces.

Opposite: Mary by the Window
11 x 15 cm (4 x 6 in) Khadi rough paper
Colours: Burnt Sienna and Sepia

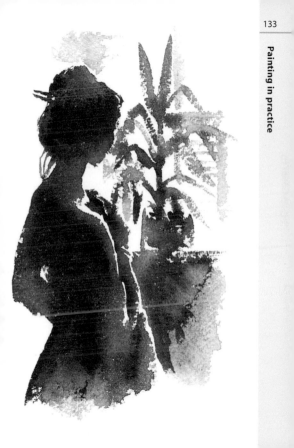

PLACES

Painting successful 10-minute watercolours on
location depends on the temperature and humidity
of the environment. In hot, dry weather, watercolour
dries quickly so you can build up layers of colour
wet-on-dry. If the weather is cold or damp, drying
times are slow so you will need to work wet-in-wet
or paint features straight onto dry paper.

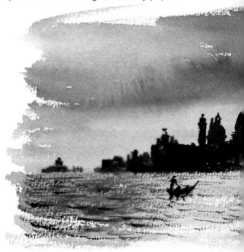

Watercolour papers dry at different rates and usually a rough surface takes longer to dry than a 'not' surface. Using less water in your mixtures shortens drying times and engaging the use of the car heater, if available, can be a useful aid.

'Planning', or thinking ahead, is the secret to swift watercolour painting. Choose your method and select your colours before you begin painting.

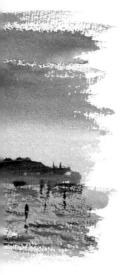

Santa Maria della Salute at Sunset
22.5 x 30 cm (9 x 12 in)
Two opposite colours were squeezed into the palette: Quinachrodine Gold and Winsor Violet. Evaporation is slow at sunset so the background wash was painted just wet enough for the brushstrokes to merge. After 5 minutes' wait, the silhouette of the buildings was painted with dry paint using the moisture from the background to blend the brushstrokes. Dry brush technique was used for the water.

FIELDS AND TREES

Creating a landscape scene necessitates a background.
These two paintings show different approaches.
By dry-brushing the sky the treeline could be added
immediately and it remained crisp-edged. The
buildings on the crest of the hill could also be added
without worrying about the colours running into a

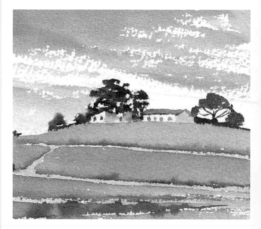

Dry-brushed sky

The paths between the vineyards acted as margins between
wet washes and were tinted only after the fields had dried.

wet sky. In contrast, the wet sky wash (below) took more time to dry so the trees were added wet-in-wet.

The drier and more intense the added colour, the easier it is for you to control the spreading shape of individual trees. The field wash was brought up from the bottom of the picture to meet but not mingle with the colours on the skyline.

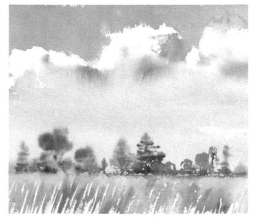

Wet-washed sky
The cornfield was given depth by reserving white paper for the foreground stalks of corn.

Individual trees

If there is not time to paint a scene, a sketch of an individual tree or group of trees is a satisfying way to spend a few minutes.

The flick of a brushstroke seems readymade for painting certain trees. The massed needles of the pine and the fronds of the palm tree flow naturally from the end of the brush.

Pine tree
The trunk of the pine tree was painted as a straight line. The branches were painted across it with swift, upturned zig zags so the lines merged.

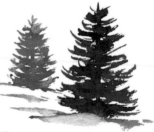

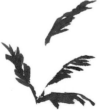

Palm fronds
To paint these, start either from the tip or base of the leaf and show the overall shape rather than delineate individual fronds.

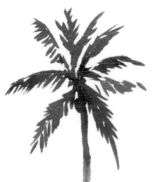

Palm tree
I worked fast so the fronds blended at the centre, then added the trunk wet-in-wet so the colour merged with the leaves. This tree took less than a minute to paint. The colours used were Raw Umber, Prussian Blue and Cadmium Red.

Deciduous tree
The abundant foliage was given volume by touching darker colour wet-in-wet into the right-hand clumps of foliage. Slow-drying Khadi paper was used, which enabled the trunk and branches to merge with the leaves. Sap Green and Burnt Umber were applied with a size 6 mop.

SKIES

Most landscape paintings require some form of sky. To paint quickly the sky wash must dry as fast as possible or the landscape details must be painted wet-in-wet.

As skies often lighten near the horizon this area of the paper can be lightly or barely painted so that it dries fast, ready for features that require crisp edges.

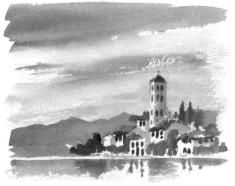

Island Monastery
15 x 20 cm (6 x 8 in) Arches rough paper
Colours: Cobalt Blue, Yellow Ochre, Cadmium Red
Brushes: 12 mm (¹/₂ in) flat brush and size 6 round sable
Time: 8 minutes

Skies influence the colour of the land or sea beneath. Use the same blues, yellows and reds in the sky to make the colours of the land or seascape; this ensures unity in the painting and speed.

The sun and its reflection

In the painting below, by reserving the sun and its reflection with wax resist, the sky and sea wash could travel freely all over the paper, thus speeding up the painting process.

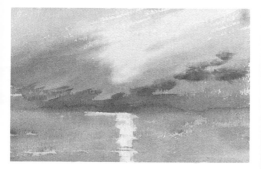

Brief Sunset over the Ocean
22.5 x 30 cm (9 x 12 in) Arches rough paper
Colours: Indian Yellow, Coeruleum, Alizarin Crimson
Brush: size 8 round sable
Time: 4 minutes

Clouds

The ever-changing nature of clouds can provide perennial fascination for the brush. Skies do not have to serve as adjuncts to the landscape – they can be a subject in themselves.

Cumulus clouds

Fairweather clouds have crisp tops and soft underbellies. Starting at the top, paint the blue of the sky onto dry paper and use the heel of the brush to create crisp, ragged edges to the tops of the clouds.

Rooftop in Fleet Street

13 x 17.5 cm (5 x 7 in) The paper under the white clouds was moistened with clean water and the blues brushed in to blend softly into the undersides but still create a crisp top edge to the clouds below.

Rain-bearing clouds

The undersides of these clouds will be darker. Touch more intense colour into the shadows while the paper is moist. So long as you only add pigment and not water you will find you can manipulate the shadows to create volume in the clouds.

Snowfall

15 x 30 cm (6 x 12 in) Aquarelle paper

By tilting the paper as the colours merged, updrafts and downdrafts were created within the clouds. The falling snowflakes were made by water droplets landing on the page.

Sunsets

The dramatic colours of sunset are a watercolourist's dream. Sky colour and cloud patterns change quickly as the sun goes down, and painters often fall into the trap of chasing the changing colours, each one more intense than the colour they are actually painting. Added to that, drying times are usually slow.

It is therefore easier and less frustrating to make pencil memory notes while the sun is going down. These remind you of cloud shapes, wind direction and colours. You can then do your painting from memory after the sun has set.

In the painting opposite, the colours were blended wet-in-wet and brushed across the sky. The three colours together were used to create the silhouette of the tree.

Tree silhouette
This was sponged on with neat paint straight from the tube.

Opposite: African Sky
17.5 x 12.5 cm (7 x 5 in) Langton paper
Colours: Indian Yellow, Permanent Rose, Ultramarine Blue
Brushes: size 8 round sable and rigger

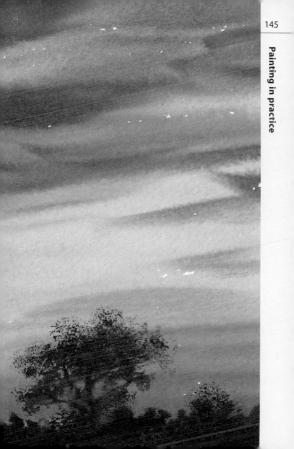

SEASCAPES

The stark shapes of white sails against a dark sky make an atmospheric seascape. The movement of the sea and wind is felt in the tilt and curve of the yacht and sail shapes.

Crests of waves

The white horses in the sea were created with a fluid sideways stroke of the flat brush whisking back and forth across the paper, leaving out slivers of white paper from the wash as it went. While it was wet, Yellow Ochre was blended with the blue to create variation in the colour of the sea.

White sails

The shapes of the sails were lightly drawn in pencil. The paper was wetted around them with clean water. The dark sky was brushed in carefully around the sails.

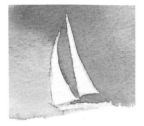

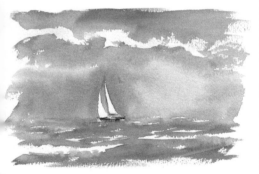

Surfing the Waves

15 × 22.5 cm (6 × 9 in) Arches rough paper

Colours: Tropical Phthalo Blue, Yellow Ochre, Quinachrodine, Magenta

Brush: 12 mm (1/2 in) flat brush

Time: 6 minutes

Breaking waves

The sea has many of the properties of watercolour: translucency, fluidity, colour, crisp whites and intrigue. The breaking waves defy replication no matter how long you study them. Summarize the movement and simplify.

1 The underside of the wave is painted first, leaving white paper where the foam tumbles over the crest. Viridian and Aureolin are blended for the translucent green of the rising wave and merge wet-in-wet with Tropical Phthalo Blue at the base. Dry brushwork is used to suggest the broken water in front of the wave.

2 The area above the breaking wave is moistened with clean water. The blue of the sea is brushed in above the crest, avoiding the wet area into which it blends softly, indicating the spray.

3 The distant landscape and lighthouse are painted above a strip of unpainted paper to show the line of the beach. The foreground sand is a mixture of Aureolin and a dash of Quinachrodine Magenta (any red in the palette will do).

Surf

17.5 x 12.5 cm (7 x 5 in) Arches rough paper

Colours: Viridian, Tropical Phthalo Blue, Aureolin, Quinachrodine Magenta

Brush: size 8 round sable

Time: 8 minutes, with extra minutes spent strengthening the wave, sand and background the next day

Rocks

The solid forms of rocks, their myriad shapes and granular textures are a delight for playing with watercolour. The contrast of deep shadows, mid tones and stark highlights makes it easy to suggest the third dimension on paper.

Form
With a light tone, mid tone and dark tone you can create form in the rock.

In the composition opposite of several rocks, highlights were contrasted against shadows (light tones against dark tones) to show one rock is in front of or on top of another. The rocks were drawn quickly with a graphite pencil and wax candle was rubbed on the paper to reserve textured highlights.

Shadows
Broad strokes of the same blue as the sky demarcate the shadows under each of the boulders.

Yellow Ochre and Burnt Sienna were painted over the wax to cover the mid tone areas. Intense mixes of the other colours were painted freely wet-in-wet into each corner and crevice until the tones were dark enough for the deep shadows.

If time is pressing, you can add finishing touches to a watercolour later. In the picture below, when the sand wash had dried, the foreground was spattered with colour flicked from a toothbrush.

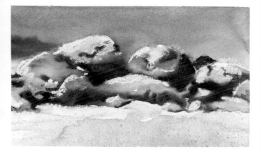

The Rocky Beach
30 x 40 cm (12 x 16 in) Bockingford paper
Colours: Ultramarine Blue, Yellow Ochre, Burnt Sienna, Alizarin Crimson
Brushes: 25 mm (1 in) flat brush and size 8 round sable
Time: 10 minutes

STILL WATER

Throughout the day the gentle waters of a lake change in colour and mood. One sheet of paper was divided with masking tape into eight sections to record its moods (opposite). Different techniques were employed in each case.

Opposite: The colours of change

1 The sky and hills were painted in three overlaid tints. The lake was dry-brushed with a 12 mm (1/2 in) flat brush.

2 Ultramarine Blue and Burnt Sienna were brushed across wax to create the sparkle of backlit water.

3 A lilac sky breaks into dry brush for the streaks of reflected light. The hill tint continues into the ripples.

4 Wax was scribbled across a dry Yellow Ochre wash. Pale Ultramarine and Alizarin Crimson were then overlaid to suggest the sun breaking through mist.

5 The reflection was painted wet-in-wet but the island was painted wet-on-dry (Prussian Blue and Yellow Ochre). The ripples were added in Chinese White with just the tip of a brush.

6 Ripples were created with untouched paper left between brushstrokes in a Prussian Blue and Yellow Ochre wash.

7 This time the ripples of light were scratched off with a scalpel blade.

8 The water and sky remain the same tone but the ripples were painted with the animated tip of a size 6 brush.

1

2

3

4

5

6

7

8

DISTANCE

Just as three tones can suggest form in a still life, so they can suggest depth in a landscape even though they represent a much larger scale. In this painting, just three basic tones – the sky, the sea

Table Mountain, Cape Town, South Africa.
11 x 28 cm (4 x 11 in) Saunders Waterford Paper, not surface
Colours: Viridian, Coeruleum, Alizarin Crimson
Brush: 25 mm (1 in) flat brush
Time: 5 minutes

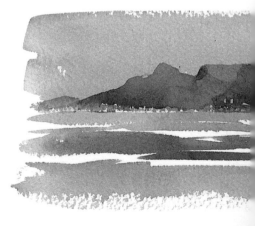

and the mountain – create a sense of space and distance to leave you with a great memory.

Tone 1: A light sky is brushed in with a 25 mm (1 in) flat brush.

Tone 2: The same colour is enriched to create the strips of waves, leaving some white paper showing.

Tone 3: The mid tone is painted onto the sky wash to represent the shape of Table Mountain (tone 1 + tone 2 = tone 3). Small flecks of untouched white paper indicate the city at its base. Touches of darker colour show the overlap of mountain forms.

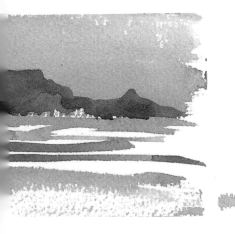

SNOWY MOUNTAINS

Snow is perhaps the easiest of all the subjects for a watercolourist to paint because you don't actually paint it... all you do is brush in a few blue shadows and leave lots of white gaps of pristine paper.

Areas of unlit snow look blue in colour so the sky wash in this painting, with an added touch of Paynes Grey, was continued for the long shadows. Ridges of white separate the wet washes so the painting could be completed quickly from top to bottom. Small touches of Paynes Grey were touched into the wet paint on the foreground slopes to show incidental forms.

Mountain ridges

A pencil sketch was made of the mountain ridges to guide the brushwork.

Fir trees

These were painted with a size 6 brush in a stronger, quite dry, mix of the blue and grey.

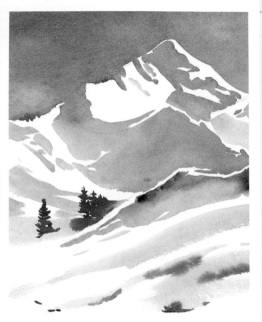

The Peak
40 x 30 cm (16 x 12 in) Bockingford paper
Colours: Ultramarine Blue, Paynes Grey, Yellow Ochre
Brushes: 25 mm (1 in) flat brush and size 6 brush
Time: 8 minutes

HOLIDAYS

Quick sketches from a happy holiday are a great memory. Keep them together in a sketchbook and they'll be more gratefully viewed than holiday snaps.

Waiting for a drink, watching a golf game, sunning by the pool – all these occasions can offer 10 minutes for a quick watercolour sketch, and there is also a sense of achievement in having something to show for your day. All you need are a small palette and a pad.

18th Hole
10 x 10 cm (4 x 4 in) Khadi rough paper
Colours: Aureolin, Prussian Blue, Alizarin Crimson
Brushes: size 6 round and 12 mm (1/2 in) flat
Time: 6 minutes

My Sunhat on the Deck
12.5 x 10 cm (5 x 4 in)
Khadi paper
Colours: Permanent Rose,
Yellow Ochre, Prussian Blue
Brushes: sizes 6 and 8
round sables
Time: 10 minutes

We often have favourite items of clothing, and these can make great subjects for a holiday watercolour. The sunhat above scoops up the sunshine.

Wish You Were Here!
This deckchair was painted on a blank postcard. You can buy them in blocks of watercolour paper and send personalized images to your friends.

TOWNS AND CITIES

The vibrant life of cities and street scenes can be painted swiftly if you are brave enough to paint in full public view. The flat brush is the perfect tool for capturing the essence of the urban landscape. In this painting, the taxis are painted with Indian Yellow. The buildings are added above them from the middle, with attention only to their shape against the sky.

Angular buildings
Downward brushstrokes made with a flat brush were built up in layered tints, wet-on-dry, to create the cubic volume of the skyscrapers. Small horizontal strokes, also made with the flat brush, suggested the windows.

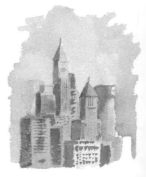

Opposite: Yellow Taxis
17.5 x 12.5 cm (7 x 5 in) Bockingford paper
Colours: Indian Yellow, Indigo, Cadmium Red, Prussian Blue
Brush: size 6 round sable
Time: less than 10 minutes

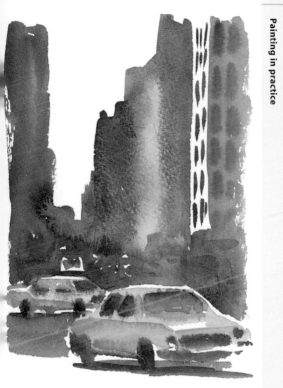

Architectural details

Small architectural details are fun to paint: there is no obligation to create a good composition and the enjoyment of observation takes precedent.

Make a light pencil sketch to locate the positions and proportions of windows, doors, archways, etc. As you paint, avoid working exactly to the pencil lines – let your brushwork criss-cross them freely.

In these fragments of stonework, painted in a village, the warm colour of the stone was painted with Raw Umber and Yellow Ochre. The pencil guide enabled the 'details' to be added with small, swift strokes of neat Sepia using the tip of a size 6 round brush. If you work slightly wet-in-wet your brushstrokes will suggest more detail than you actually paint.

Watercolour sketches in the town of Oundle
Each sketch took a few minutes in a Saunders watercolour hardback sketchbook.

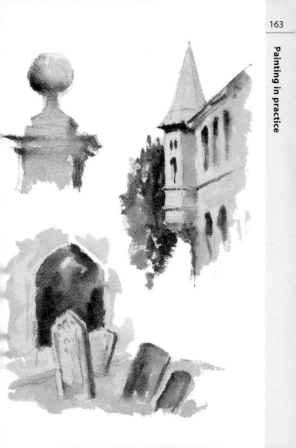

ANIMALS

Painting animals from life is not easy. You will need to be patient… or paint them when they are asleep! It may take several attempts before you are satisfied with even one sketch. Start by making quick observational pencil or brush outlines of the head, limbs and torso shape.

Yassen
No time for detail here, but the rough edge of the brushstroke creates a living sketch. This took 10 seconds using Burnt Sienna with a size 8 brush.

Painting the animal's shape directly onto paper without a preliminary drawing provides a wet-in-wet wash within which you can paint more detail if time allows. A rough surface paper will give your brushstrokes life.

Feeding the lambs
Drawing with a brush rather than a pencil creates a fluid sketch.

Tabby cat
As familiarity grew, the markings
were added wet-in-wet into the
body shape of the cat.

HORSES

The graceful shape of the horse makes it a popular subject for artists. A horse race is an ideal setting for quick paintings because everyone is so intent on the race that they take no notice of artists.

Horses, Sandown

These individual sketches were painted on Saunders Waterford paper, using Burnt Sienna and other colours in my palette and a size 6 round sable. Leaving lozenges of white paper highlights suggested form and also showed the glossiness of the horse's back in the lower right-hand sketch.

The parade ring is a good place to paint. Unless you feel obliged to make a particular likeness, you can use several horses to make up one sketch as they move around the ring.

Galloping by

When the horses are running there is no time to look down at the paper so just use a pencil and let it flow without trying to correct it. You will be surprised to find that you can draw quite well without looking down. After the race, paint watercolour into any of the sketches that work. Use the blur of wet-in-wet blends to suggest speed, and dry brush for movement.

BIRDS AND BACKGROUNDS

Reserving white paper from a wash is one of the most elegant qualities of watercolour, so painting a white or highlit animal against a darker background makes a fine subject.

Seagull
A pencil sketch shaped the seagull and noted the shadows. A variegated wash gave the shadow charm.

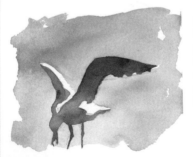

Sky wash
When the paint was dry, the sky wash was used to complete the highlights.

The swan below was outlined in pencil. A rich mix of Aureolin was brushed down from the top, around it. Prussian Blue was brushed up from the bottom, leaving strips of white paper for the reflection. The blue was carried into the wet yellow wash to create a dense green background around the swan. Khadi paper is slow to dry, which helped the colours blend.

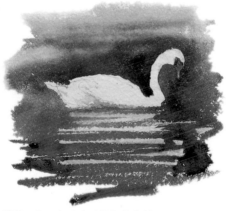

Gliding the Lake, Painshill Park, Cobham
12.5 x 12.5 cm (5 x 5 in) Khadi rough paper
Colours: Aureolin, Prussian Blue, Cadmium Orange, Ivory Black
Brushes: sizes 6 and 8 round sables
Time: 4 minutes

WILDLIFE

Painting wildlife requires speed but animals that have not been threatened by man can be curious and do not immediately run away. Often they hold their pose for long enough for you to draw their shapes, and, if the paints are ready, they can be painted directly into the sketchbook.

Sometimes only a camera can catch the pose, so if you are working from photographs back home try to paint the animals with the same immediacy that you would need in the wild – this prevents them being static.

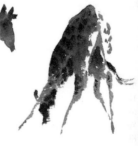

Giraffe
A size 6 brush loaded with Burnt Sienna was used to paint the giraffe shape. The patchwork markings were touched in wet-in-wet.

Meerkats in the Kalahari

These quick sketches were
made with Prussian Blue,
Yellow Ochre and Sepia on
Khadi paper. While the body
wash was wet, the eyes, nose, feet, shadows and patina of
the fur were touched in with almost neat Sepia on the tip
of a size 6 round sable brush.

Elephants

No book of mine would ever be complete without elephants! The beauty of painting animals in a herd is that if one animal moves on, another will usually take up its place with a similar pose.

Elephant
Starting with the animal's head, I worked with rich wet paint on a rough paper so that the wash stayed wet in case I had to continue the pose with another elephant.

First wash
The first wash defines the shape of the elephant with a colour suitable for the lightest parts (Yellow Ochre).

Young Elephant
7.5 x 7.5 cm (3 x 3 in) Arches rough paper
Colours: Winsor Violet, Indanthrene Blue
Brush: size 6 round sable
Time: 6 minutes

The concave and convex forms of this elephant's
body were created wet-in-wet with strong
Winsor Violet. Indanthrene Blue was added for
the shadows behind the ears and back of the legs.

STILL LIFE

The realm of 'things' is appropriately called 'still life'. You can make a 10-minute watercolour without worrying about a subject moving, and the danger of overworking a painting is reduced with the limited time. Look around you in your spare minutes: watercolour painting is fun and anything can be its subject.

Fruit, with its bright colours and textures, is a delightful subject. Here a combination of wet and dry brushwork created the sumptuous form of the pineapple.

Pineapple
17.5 x 10 cm (7 x 4 in)
Arches rough paper
Colours: Quinachrodone Gold,
Indian Yellow, Sap Green,
Tropical Phthalo Blue
Brush: size 8 round sable
Time: 7 minutes

Fresh Coffee
15 x 10 cm (6 x 4 in) Arches rough paper
Colours: on the palette
Brush: size 6 round sable
Time: almost 10 minutes

The steam from the hot coffee (above) was created
by blending the background either side into wetted
paper, then dabbing out excess colour with a tissue.

HOUSEHOLD OBJECTS

A lot of everyday household items are made in the round. To give a painted object form, simply create a gradation of tone across the surface from light to dark.

Rounded form is implied on the outside of this jug by gradation of tone. The interior space was created with very dark tone applied wet-in-wet which lightens near the rim.

Chinese Jug
12.5 x 10 cm (5 x 4 in)
Arches rough paper
Colours: Cobalt Blue,
Yellow Ochre, Indigo
Brushes: sizes 6 and
8 round sables
Time: 9 minutes

Chinese Teapot
15 x 15 cm (6 x 6 in) Arches not paper
Colours: Ultramarine Blue, Yellow Ochre, Cadmium Red
Brushes: sizes 6 and 8 round sables
Time: 8 minutes

The rounded shape, the high-lit patches and the use
of the background to bring out the top lights in this
teapot suggest form without the need for much tonal
variation over the surface.

FOOD AND WINE

Most of us love food, and painting it is equally delicious. A small palette, brush and sketchbook will make it possible to paint in any restaurant or bar. When you are eating alone it's a great way either to meet people or fend them off, whichever you prefer!

Breaking Bread

20 x 30 cm (8 x 12 in) Arches rough paper

Colours: Yellow Ochre, Quinachrodone Gold, Ultramarine Blue, Burnt Sienna

Brushes: sizes 6 and 8 round sables

Time: a little longer than 10 minutes!

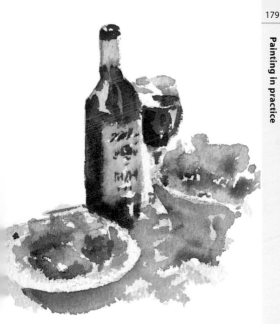

Al Fresco
12.5 x 10 cm (5 x 4 in)
Colours: Ultramarine Blue, Alizarin Crimson, Yellow Ochre,
Aureolin, Indian Yellow, Winsor Green, Cadmium Red
Brush: size 6 round sable
Time: 8 minutes

FRUIT AND FLOWERS

If you enjoy colour, painting fruit and flowers gives you the chance to use some bright colours and lively brushwork in an uninhibited way. When learning to paint watercolour, there is probably no better subject.

Strawberry

Cadmium Red, Alizarin Crimson and Sap Green made a mouthwatering strawberry in just a few minutes. The highlight and flecks of reserved Khadi paper are the secret to its glossy look.

White flowers

How do you paint white flowers? Simply by painting the background around them. Cobalt Blue and Yellow Ochre make an excellent grey for the delicate shadows on the white petals.

Pot of Geraniums
30 x 25 cm (12 x 10 in) Saunders Waterford paper
Colours: Aureolin, Prussian Blue, Cadmium Red
Brush: size 10 round sable
Time: 7 minutes

Aureolin and Prussian Blue were sponged around the masked flowers above. When dry, a wash of the same green was laid on top, the masking was removed and the geraniums were touched in with Cadmium Red.

Ripening lemon

The sheen on fruit and its roundness is suggested easily by leaving a small lozenge-shaped highlight of untouched white paper on the lit side of the fruit.

Lemon
This lemon was painted with Aureolin and then a more intense mix of Aureolin, plus a dash of Prussian Blue and a speck of Alizarin Crimson was added wet-in-wet at the base with the tip of the brush. The colour spread into the yellow, creating a gently rounded shape.

Leaf
The leaf was painted from tip to stem in one brushstroke, starting with the tip of the brush and then pressing down onto the heel to make the leaf broader. At the stalk, the brush was twisted back to a point and lifted off.

Ripening Lemon
23 x 15 cm (9 x 6 in)
Saunders Waterford paper
Colours: Aureolin, Prussian
Blue, Alizarin Crimson
Brush: size 8 round sable
Time: 7$\frac{1}{2}$ minutes

Hibiscus

The speed of painting wet-in-wet is ideal for the organic nature of flowers. Do not be afraid to mix plenty of colour and to add strong, intense paint.

Petals

The petal shapes were painted by pressing a fully loaded brush, heel to tip, onto the paper in a rotating motion. The body of the brush unloaded its pigment near the

centre of the flower whilst the tip released less paint, creating a ragged edge. Intense colour was brushed in wet-in-wet to show overlapping petals and the dark centre.

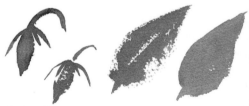

Buds and leaves

The bud and leaf shapes were painted with a light broad stroke, which broke across the tooth of the paper. Note how a broken wash is more interesting than a solid one.

Hibiscus
19 x 16 cm (7 x 5 cm) Arches rough 140lb paper
Colours: Permanent Rose, Indian Yellow, Prussian Blue,
Alizarin Crimson
Brush: size 8 round sable
Time: 8 minutes

PEBBLES

If you only have time to do one painting and you want to try out all the techniques mentioned in this book, a good subject is a pile of coloured stones. You can even make them up from your imagination.

Simple shapes
Draw a collection of rounded shapes (above). Rub wax over some for texture. Wash a pale yellow, red and blue across the page. Into the wet wash draw round the pebble shapes with an intense mixture of the red, blue and Indigo, making it particularly deep in dark corners.

Water-washed pebbles

...at the tops of one or two stones (below) with a tissue to ...top the colour spreading. As the washes dry, dab a sponge ...ipped in yellow or Chinese White onto the surfaces of some ...tones to create more texture. Draw thin vein lines with a ...gger and make dry brush marks with a fanned brush. All the ...echniques you have learnt put into practice in 10 minutes!

FURTHER INFORMATION

Here are some organizations and resources that you might find useful.

Art Magazines

The Artist
Caxton House, 63/65 High St, Tenterden, Kent TN30 6BD
tel: 01580 763673
www.theartistmagazine.co.uk

Artists & Illustrators
The Fitzpatrick Building, 188–194 York Way, London N7 9QR
tel: 020 7700 8500

International Artist
P. O. Box 4316, Braintree, Essex CM7 4QZ
tel: 01371 811345
www.artinthemaking.com

Leisure Painter
Caxton House, 63/65 High St, Tenterden, Kent TN30 6BD
tel: 01580 763315
www.leisurepainter.co.uk

Art Materials

Daler-Rowney Ltd
Bracknell, Berkshire RG12 8ST
tel: 01344 424621
www.daler-rowney.com

Winsor & Newton
Whitefriars Avenue, Wealdstone, Harrow, Middlesex HA3 5RH
tel: 020 8427 4343
www.winsornewton.com

Art Societies

Federation of British Artists
Mall Galleries, 17 Carlton House Terrace, London SW1Y 5BD
tel: 020 7930 6844
www.mallgalleries.org.uk

Society for All Artists (SAA)
P. O. Box 50, Newark, Nottinghamshire NG23 5GY
tel: 01949 844050
www.saa.co.uk

Bookclubs

Artists' Choice
P.O. Box 3, Huntingdon,
Cambridgeshire PE28 0QX
tel: 01832 710201
www.artists-choice.co.uk

Painting for Pleasure
Brunel House,
Newton Abbot,
Devon TQ12 4BR
tel: 0870 4422 1223

Videos

APV Films
6 Alexandra Square,
Chipping Norton,
Oxfordshire OX7 5HL
tel: 01608 641798
www.apvfilms.com

Teaching Art
P.O. Box 50, Newark,
Nottinghamshire NG23 5GY
tel: 01949 844050
www.teachingart.com

Internet Resources

Art Museum Network
www.amn.org

Artcourses
www.artcourses.co.uk

The Arts Guild
www.artsguild.co.uk

British Arts
www.britisharts.co.uk

British Library Net
www.britishlibrary.net/
museums.html

Galleryonthenet
www.galleryonthenet.org.uk

Hazel Soan
www.hazelsoan.com
www.allsoanup.com

Painters Online
www.painters-online.com

WWW Virtual Library
www.comlab.ox.ac.uk/
archive/other/museums/
galleries.html

Index

INDEX